XENA
WARRIOR PRINCESS

*Based on the tevevision show created
by John Schulian & Robert Tapert
Adapted by John Whitman
Illustrated by Jeff Albrecht & Gary Kwapisz*

CHRONICLE BOOKS

SAN FRANCISCO

Library of Congress Cataloging-in-Publication Data available.

ISBN 0-8118-2207-9

Printed in Hong Kong

A First Street Films Book

Composition by Margery Cantor

Distributed in Canada by Raincoast Books
8680 Cambie Street
Vancouver, British Columbia V6P 6M9

10 9 8 7 6 5 4 3 2 1

Chronicle Books
85 Second Street
San Francisco, CA 94105

www.chroniclebooks.com

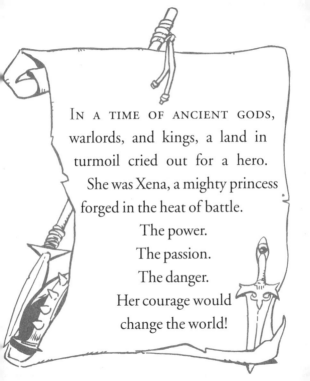

IN A TIME OF ANCIENT GODS, warlords, and kings, a land in turmoil cried out for a hero. She was Xena, a mighty princess forged in the heat of battle.
The power.
The passion.
The danger.
Her courage would change the world!

Xena first entered the chronicles of history in the lands near Arcadia. She was already a great warrior in command of a terrible army, but as yet her fame had not spread for one simple reason: almost no one who faced her lived to tell the tale. In those days, Xena was not a hero, but a villain who terrorized the countryside, raiding villages and plundering cities.

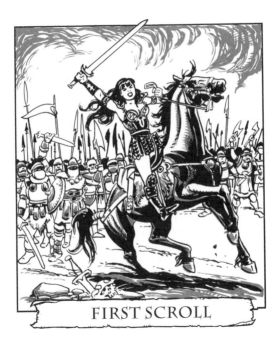

FIRST SCROLL

As her next conquest, Xena set her sights on the land of Arcadia itself. But Xena knew that before she could invade, she had to remove the one obstacle that could defeat her plans.

Hercules.

Sparks flew as Hercules hammered hot iron into shape. Beside him, his best friend, Iolaus, worked the bellows to keep the furnace hot.

Sparks flew as Hercules hammered hot iron into shape.

Together, they were forging a new knife. The edge was razor-sharp.

As the metal cooled, Hercules admired the new weapon. Then, smiling, he gave it to his friend. "It's yours."

"What are you talking about?" Iolaus said. "We both worked on it."

"I'll get the next one we make. What do you say?"

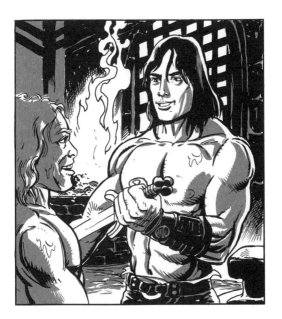

"It's yours."

Iolaus frowned. Then he laughed. He needed a new knife anyway. "I say it's the best idea you've had today."

At that moment, miles away, an innocent-looking young woman strolled through a small village toward the public well.

The woman filled her bucket, seemingly unaware that five armed men lurked nearby.

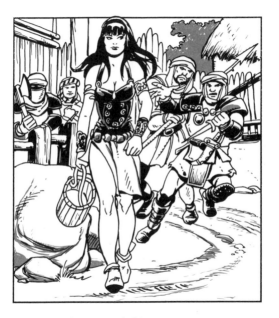

An innocent-looking young woman strolled through a small village.

"That's her," one of them whispered. "Get her."

One of the men drew a knife and lunged at the helpless young woman from behind.

Spinning around, the woman slammed her bucket into the attacker's face. The other men charged, but the woman was too quick. The second man fell before he could even reach

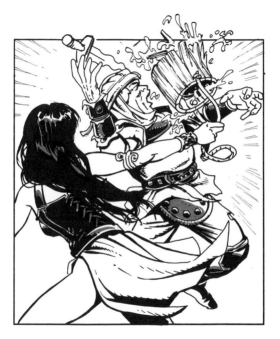

The woman slammed her bucket into the attacker's face.

her. The third slashed at her with a
sword, but the woman dove over the
blade. As she rolled, she kicked the
fourth in the face, stopping him cold.
Quick as a serpent, the woman leaped
to her feet in time to block the blows
of the fifth. She dropped him with a
single punch. The third man attacked
her with his sword again, but the
woman dodged the blows and kicked

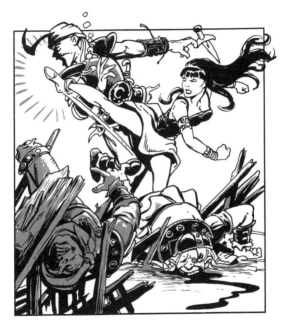

She kicked the attacker in the face, stopping him cold.

the swordsman hard in the ribs. He fell like a toppling tower.

The woman sneered at the five fallen warriors. The look of the innocent young maiden was gone. In its place, all could see the hard glare of Xena, Warrior Princess.

"Pathetic!" Xena spat. "If you can't fight better than that then you're never

"Pathetic!"

going to defeat Hercules. And I want him dead!"

Xena's eyes narrowed. She could never beat Hercules with brute force. She would have to create a more devious scheme.

A few days later, Iolaus walked slowly down the road to the village.

As he reached a bend in the road, he

Iolaus walked slowly down the road to the village.

saw a beautiful woman kneeling beside an injured horse.

"Need any help?" he called out.

The woman whirled around and drew a knife, trembling with fright. "Stay away!"

Iolaus raised his hands. "Easy. I'm not going to hurt you. But if you put that knife away, I can help you get to the village."

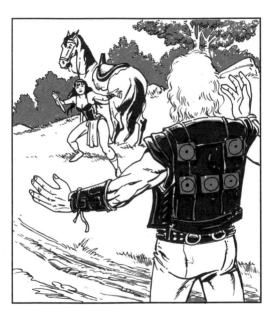

"Stay away!"

Hesitantly, the woman lowered her knife, and Iolaus approached and examined the injured horse.

Behind his back, Xena smiled. The first part of her plan had worked perfectly.

Hercules spent the entire afternoon searching for Iolaus. Finally, as night fell, he checked the tavern, and

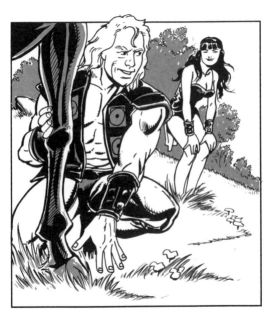

Behind his back, Xena smiled.

found his good friend deep in conversation with a beautiful woman.

"You were supposed to help me build a wall at my mother's house," he said.

"Something came up," Iolaus replied. "Hercules, this is Xena."

"Hello," Xena said innocently. "Iolaus came to my rescue today."

"Did he now?" the son of Zeus smiled. "Well, he's that kind of guy.

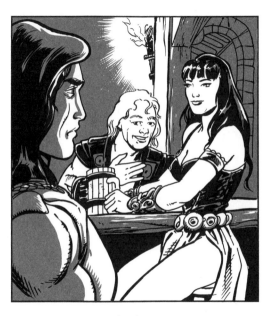

"Hercules, this is Xena."

Say, why don't we all have dinner together?"

Xena shook her head and smiled seductively at Iolaus. "I think I'd be better off looking for a soft, warm bed. Think you could help me one last time?"

Iolaus blushed deep red. "Yeah, I . . . uh . . . I think that can be arranged." He patted Hercules on the shoulder.

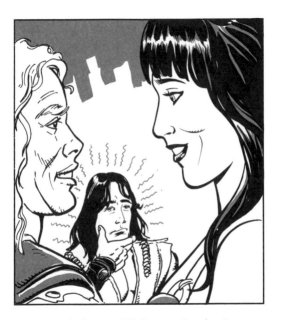

"Think you could help me one last time?"

"See ya."

"Uh-huh," Hercules replied, scratching his chin thoughtfully.

━━◯ Hercules didn't see Iolaus for a week, as Xena held the blond warrior enthralled. Working at his mother's house, the son of Zeus grumbled, "Iolaus doesn't know a thing about this Xena. What if she's got a jealous husband?"

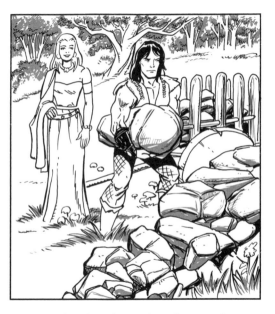

"Iolaus doesn't know a thing about Xena."

"What if she's the best thing in the world for him?" Alcmene replied.

Hercules did not reply. Some instinct told him his mother was wrong, but as yet he could prove nothing.

As Hercules worried, Iolaus lay in Xena's arms. Xena kissed him passionately, then suddenly pulled away. "I . . . I don't want you to fall in love with me," she warned.

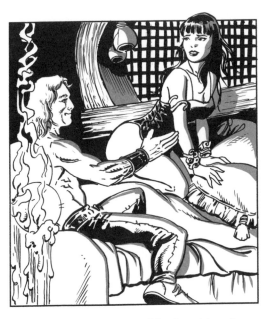

"I . . . I don't want you to fall in love with me."

"It may be too late," Iolaus admitted.

Xena sighed. "I was hoping I'd be the only one to go away from this with a broken heart."

Iolaus held Xena's hands, his eyes filling with love. "You don't have to go away. I want you here."

Xena hid a smile. The time had come to spring her trap. Her people, she said, were under siege by a terrible

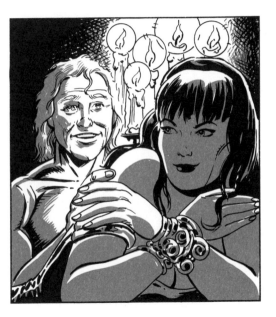

"You don't have to go away."

warlord named Petrakis. "I'm building an army to defend them," she said.

Suddenly, Iolaus realized, "You came to get Hercules, didn't you?"

"Yes," Xena admitted, "but I found you."

"Then I should be the one you ask for help!" Iolaus said.

Xena smiled. She had Iolaus right where she wanted him.

"Then I should be the one you ask for help!"

Later that night, Xena crept away from Iolaus to meet with one of her warriors, a man named Theodorus.

If her plan was to work, Hercules must know that she was not what she claimed to be. Taking an amulet from around her neck, she gave it to Theodorus, and she ordered him to kill the son of Zeus.

The trap was set.

She ordered him to kill the son of Zeus.

The next day Iolaus and Xena rode to Alcmene's house, where Hercules was hard at work. Proudly, Iolaus announced that he was going to battle the evil warlord Petrakis.

"Is there anything I can do?" Hercules offered.

"No!" Xena replied quickly. "Iolaus is all the help I need."

As they passed out of sight, the son

"Is there anything I can do?"

of Zeus hurried back into his mother's barn for more supplies, his arms loaded with tools. A rake slipped from his grasp, and as he bent down to pick it up, something whistled over his head. *Thok!* A knife sank into a wooden post behind him. Hercules leaped back as the warrior Theodorus stepped out of the shadows.

Thok! *A knife sank into a wooden post behind him.*

"You know, a true warrior attacks from the front," Hercules said.

Theodorus sneered, "My commander says you attack from whatever side suits your purpose."

Hercules shrugged. "So . . . he's a coward, too?"

Enraged, Theodorus hurled another knife. Hercules threw up a wooden shovel and the knife bit into it.

Enraged, Theodorus hurled another knife.

Theodorus was already in motion, coming in fast behind the knife throw. He jabbed another dagger at his foe, but Hercules blocked it, then tossed the assassin across the room.

Theodorus rolled to his feet, dagger still gripped tightly.

"Ah-ah," Hercules taunted. "Better try something else."

Grinning, Theodorus dropped his

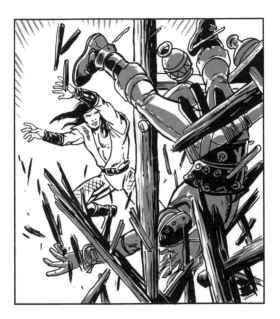

Hercules tossed the assassin across the room.

knife and drew a wicked-looking sword.

Hercules muttered, "Me and my big mouth."

The assassin slashed, but his blade cut nothing but air as Hercules ducked and scrambled up a set of rotting stairs. Theodorus slashed again, but the wild stroke missed the son of Zeus and sliced a chunk out of the

The assassin slashed, but his blade cut nothing but air.

barn wall. As the assassin brought the sword around, he lost his balance and crashed against the stair rails. The rotting wood cracked, and Theodorus tumbled off the steps to the floor below, crashing onto the rake Hercules had dropped. The force of his fall drove the rake's teeth right through his chest.

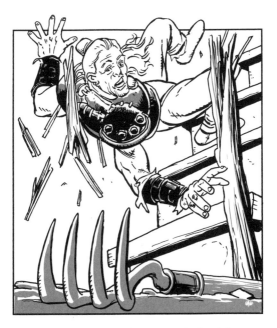

Theodorus tumbled off the steps to the floor below.

Hercules rushed to the assassin's side, but he could see the blow was fatal.

"Xena," Theodorus gasped, "I'm sorry I failed you." Then his eyes closed forever.

What is he talking about? Hercules wondered. His eyes fell on the amulet the assassin held. He'd seen the same pendant around someone else's neck.

"Xena."

"Xena, I'm sorry I failed you."

Meanwhile, Iolaus and Xena arrived at Xena's fortress, where an army prepared for war.

Leading Iolaus through a crowd of suspicious warriors, Xena took him to her private chambers, and there she bathed him in a tub of warm water.

Enjoying her gentle touch, Iolaus could not help but wonder how such

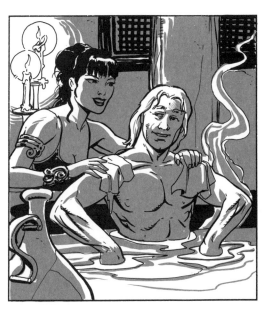

She bathed him in a tub of water.

a beautiful woman could lead such a powerful army.

"Hard times breed hard people," she explained. "My father was killed in battle. So was one of my brothers." She clenched her teeth and vowed, "I won't be."

"I admire your determination," Iolaus said worriedly. "But somewhere out there is a warlord who'll wade

"Hard times breed hard people."

through an ocean of blood to defeat you."

Xena smiled coyly. "Sounds like you're worried about me."

Iolaus laughed. "I am. It's not every day I meet a beautiful woman who wants to wash my back."

Xena's smile turned as smooth and seductive as silk. "Oh, I will do more than that, Iolaus. Much more."

"Oh, I will do more than that, Iolaus."

Slipping her gown from her shoulders, Xena stepped into the bath beside him.

But at that moment a guard pounded on the door. "Hercules is here!" came a muffled voice.

Iolaus was shocked. "What's he doing here?"

Xena saw her chance, and purred,

"Hercules is here!"

"Maybe he doesn't think you're man enough to help me."

Iolaus stiffened. Dragging on his clothes, he strode down to the courtyard, where the son of Zeus stood waiting.

"I didn't expect to see you here," Iolaus said to his old friend.

"I didn't expect to come," Hercules admitted.

"I didn't expect to see you here."

"You didn't have to," Iolaus shot back. "I thought we agreed on that." Hercules was his friend, but Iolaus had lived in his shadow for years. This was his chance to shine on his own.

Hercules grunted. "That was before your Warrior Princess sent someone to kill me."

Iolaus growled, "I don't like the way you're talking about a brave woman. I

*"That was before your Warrior
Princess sent someone to kill me."*

think you better turn around and go home."

"I was hoping you'd go with me," Hercules offered, but Iolaus shook his head. "No."

"Even though she wants me dead?" his old friend demanded.

"Where's your proof?"

"My word should be enough for you."

"I was hoping you'd go with me."

"It isn't!" Iolaus replied. "Not when you poison it by coming here."

"Iolaus, you have it all wrong—"

"Just get out of here!" the smaller man demanded.

"Why?" Hercules retorted. "Are you afraid of what you'll hear?"

Ignoring him, Iolaus turned to leave, but the son of Zeus grabbed his

"Just get out of here!"

arm and said, "You haven't answered my question."

Spinning back around, Iolaus landed a powerful blow that sent Hercules staggering backward. Then Iolaus stomped back into Xena's hall as Hercules watched in disbelief.

Neither of them saw Xena standing on a balcony, watching the scene with

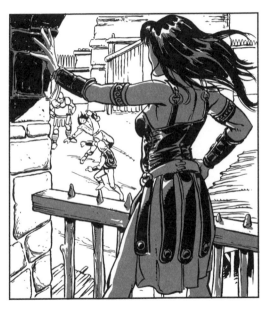

Iolaus landed a powerful blow.

a smile as sharp and wicked as a sword blade.

The sun sank over a nearby tavern, falling almost as low as Hercules' spirits. He ate a miserable meal, hardly tasting the food as he mourned the sudden loss of Iolaus' friendship. He barely noticed the whispers of those around him, as the villagers recognized the famous son of Zeus.

He mourned the sudden loss of Iolaus' friendship.

"You take care of her yet?" one of the men asked.

Hercules looked up. "I don't know what you're talking about."

"Xena," the man said, as though the word were a curse.

"She wants to write her name across history in big bloody letters," said the other man. They explained how Xena terrorized the countryside, raiding their

"She wants to write her name across history in big bloody letters."

crops and stealing their possessions. They pleaded for Hercules to help, but the son of Zeus felt his spirit fail him. "I'm sorry," he said, pushing his way through the gathering crowd, "I just don't have the strength right now."

"Wait!" an old man called.

"There's nothing more to talk about," Hercules insisted.

But the old man was wise. Looking

"I just don't have the strength right now."

into Hercules' face, he said, "Why don't we start with whatever you've lost."

Hercules looked down to the ground. "I lost the best friend I ever had. Xena got him to fall in love with her and now she's turned him against me."

The old man nodded. He had lived in the Arcadian highlands for years, and he had seen how ruthless Xena could be. "She wants everything. And

"I lost the best friend I ever had."

if she kills you, there'll be nothing to stop her."

As the sun rose over the highlands, so did the spirits of the Arcadian people.

Hercules had decided to fight for them.

He knew that he could not abandon them to Xena's onslaught, any more than he could abandon Iolaus. The

Hercules had decided to fight for them.

warlord Petrakis was little more than a lie Xena had invented. The only terrible army in the area was led by the Warrior Princess herself.

As Hercules marched toward Xena's fortress, he could not know that Xena lay in wait for him. She and Estragon hid beside the path to ambush the son of Zeus. But, eager to attack, Estragon

*She and Estragon hid beside the
path to ambush the son of Zeus.*

stirred too soon, cracking a twig. Hercules stopped, sensing danger.

"Who's there?"

With the element of surprise gone, Estragon stepped out into the open, drew his sword, and charged.

Hercules picked up a heavy stick and blocked the warrior's sword thrust. Then, with a few quick motions, he

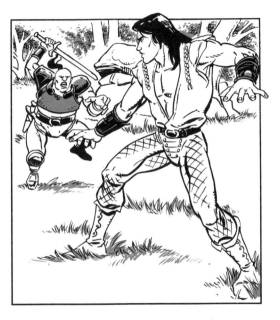

Estragon drew his sword and charged.

batted the sword from Estragon's hand and sent the killer sprawling.

Stunned by Hercules' strength and skill, Estragon gasped, "No more! I surrender!"

But surrender did not fit into Xena's warrior code. Drawing her chakram, she hurled it at her lieutenant. The razor-sharp circle sliced his throat, and Estragon fell lifeless to the ground.

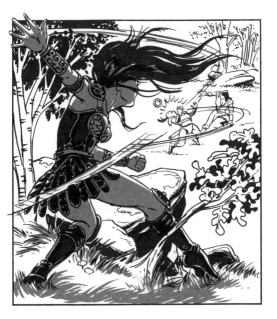

Drawing her chakram, she hurled it at her lieutenant.

Slipping away before Hercules could catch her, Xena rode back to her fortress, stopping only to smear mud across her face. As she staggered through the gates of her citadel and into the arms of Iolaus, she gasped, "He killed Estragon and he tried to kill me!"

"Who?" Iolaus asked.

"Hercules!"

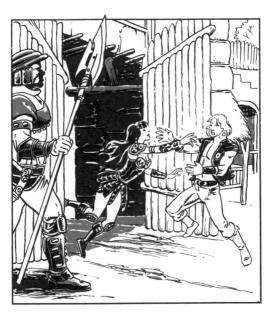

"He killed Estragon and he tried to kill me!"

Moments later, the son of Zeus reached the fortress. Iolaus snarled, "I can't believe you'd show your face here!"

Hercules' brow was clouded with anger. "Stay out of this, Iolaus. My fight is with Xena." He marched past his old friend and toward the Warrior Princess.

Iolaus barked, "You're the one that

"My fight is with Xena."

attacked Xena and killed the warrior with her!"

Hercules stopped short. "Is that what she told you? Iolaus, she's using you to get to me."

"Quit talking and get a weapon!" Iolaus ordered. Snatching up a sword, he tossed it to Hercules. As the son of Zeus caught the blade, Iolaus attacked.

The courtyard suddenly rang with

"Quit talking and get a weapon!"

the clash of metal. Iolaus' sword was a blur of motion, and Hercules barely dodged the blows, ducking and retreating to avoid the deadly attack.

"Fight, damn it!" Iolaus raged. "Quit acting like you're too good for me!"

"I'm just trying to stay alive long enough for you to come to your senses," Hercules replied.

Iolaus roared, and attacked again.

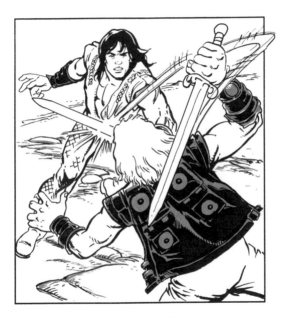

"Fight, damn it!"

Hercules knew he had to fight back, or die. Knocking Iolaus' blade aside, he sent the smaller man crashing to the floor. Iolaus lost his sword, but quick as a snake he drew his dagger—the same one he and Hercules had forged together.

"Are you going to use it?" Hercules asked.

Iolaus paused. Looking at the dagger,

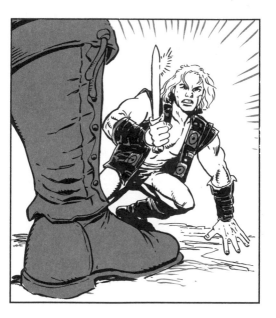

"Are you going to use it?"

and looking up at the son of Zeus, the warrior realized that he could not kill his best friend. "No," he said finally. "This knife wasn't meant to draw your blood."

Xena scowled. Her plan had failed. Their friendship had proven stronger than her hold on Iolaus. Turning to her warrior horde, she cried, "Get them!"

A small army surged forward.

"This knife wasn't meant to draw your blood."

Hercules and Iolaus stood back to back, fighting the oncoming ranks. One by one, the two men brought their enemies down. In moments, the courtyard was littered with fallen soldiers.

Hercules looked around to find Xena —but the Warrior Princess had already leaped onto her horse. Her eyes flashed as she galloped away,

One by one, the two men brought their enemies down.

promising, "You haven't heard the last of me, Hercules!"

<center>✗</center>

Xena soon formed a new army and found a new lieutenant, a hard-hearted killer named Darphus. Before long, Xena was driving her forces across the fields of Arcadia once again, burning every village in her path. Her final destination was the town of Parthis. Once

SECOND SCROLL

she had taken that important city, her conquest of Arcadia would be assured.

But Parthis was home to the cousin of Hercules, a young man named Iloran. As Xena's horde marched toward Parthis, Iloran raced off to find Hercules, knowing that only the son of Zeus could stop Xena's onslaught.

Meanwhile, Xena and her army

Iloran raced off to find Hercules.

attacked a village south of Parthis. The Warrior Princess had offered the villagers a chance to surrender. When they refused, her army descended on them like a firestorm. Every man who raised a sword against her was killed. Xena herself plunged into the battle. Wherever she fought, the enemy warriors fell by the dozens.

Every man who raised a sword against her was killed.

But only the warriors. She refused to kill helpless victims.

Darphus had no such qualms.

During the fight, Xena saw Darphus raise his sword over an unarmed old man. Before she could stop him, Darphus brought his sword down. Xena was furious, but the tide of battle swept her away.

The attack ended quickly. Everyone

Xena saw Darphus raise his sword over an unarmed old man.

in the village fled or was killed. Only one person remained alive.

"Look what we found hiding in the feed bins!" shouted a warrior.

They had found a traveling merchant named Salmoneus. He'd heard that Xena did not kill women and children, so he decided it wouldn't hurt to throw on an old dress.

"Please, don't kill me!" he begged.

"Please, don't kill me!"

"Give me one good reason!" Xena snapped.

"Um, it would be very unpleasant for me!" he stammered.

"You amuse me," Xena said. "Bring him along."

That evening, when the Warrior Princess rode north with her scouts searching for the best road to Parthis, Darphus ordered a brutal attack on a

"You amuse me. Bring him along."

sleeping village. "I don't want to see a living thing when you're through. Not a man, woman, or child! I want that village destroyed!"

And so it was. Xena's army fell on the helpless villagers without warning. Some of the victims died in their sleep. Others, half-awake, were trapped inside burning cottages. The few who escaped the fires fell beneath the sword.

"I want that village destroyed!"

The echoes of the screams had begun to fade when Xena returned from her scouting trip. "What have you done?" she roared.

Darphus would have replied, but he was interrupted by the faint cry of a baby. Throwing aside debris, Xena lifted an infant from the ashes.

"Kill it!" Darphus snapped.

One of the soldiers started forward,

"Kill it!"

then froze at the sight of Xena's fiery eyes. "You kill this baby, you die next."

She turned away, holding the baby and leading the army with her. Behind her, Darphus' eyes burned into her back.

They were long gone by the time two figures entered the smoldering ruins. Hercules and Iloran had arrived too late.

"You kill this baby, you die next."

Moving on, they soon met a young man named Spiros, who had lived in the village. Weeping, Spiros told them that Xena's forces had killed everyone, including his wife and child.

"They killed children?" Hercules trembled with anger. "I swear this won't happen again!"

Miles to the north, Xena carried the newfound infant into a cave

"They killed children?"

that served as her headquarters. There, she was surprised to find Salmoneus with a young shepherdess he had found nearby. While the woman tended to the baby, Salmoneus broached a touchy subject with the Warrior Princess.

"I . . . I don't think Darphus is on your side," he said carefully. "He's stirring up the men about saving the baby."

"I . . . I don't think Darphus is on your side."

A look of disgust crossed Xena's face. "I'll take care of Darphus."

That night, before her assembled army, Xena tried to relieve Darphus of command.

The cruel warrior grinned. "I'm afraid my men won't allow it."

Xena's eyes widened as every man in the army drew his sword and tipped its point toward Xena.

"I'm afraid my men won't allow it."

"You're the one stepping down," Darphus said to the Warrior Princess. "And you'll leave the only way a warrior can."

A rare look of concern crossed Xena's face. "The . . . the gauntlet?"

A short time later, Xena stood before two lines of warriors. Stripped of her armor, she would be forced to walk

"The . . . the gauntlet?"

between the lines. All she had to do was reach the far end alive.

"Can she really make it through that?" Salmoneus asked a guard.

The guard shook his head. "No one ever has."

Proudly, Xena started down the gauntlet. The first blows fell, spinning her around, but she kept on her feet. Then another blow fell, and another.

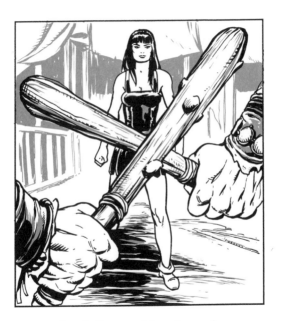

Proudly, Xena stared down the gauntlet.

Some of the soldiers attacked with clubs. Letting loose her battle cry, Xena fought back, dropping three warriors in less than a second. But she was outnumbered, and soon the hard blows rained down on her. Stumbling toward the end of the gauntlet, she fell to the ground and lay unmoving.

Darphus grinned. But as the warriors started to turn away, Xena struggled to

Letting loose her battle cry, Xena fought back.

her knees, and then to her feet. She was still alive!

"Kill her!" Darphus roared.

"She made it through," one of the warriors said. "She fought by the rules." None of the soldiers would strike her again.

Weak and beaten, Xena staggered off into the darkness and with the last of her strength, crawled back to the

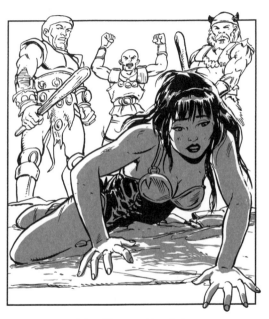

None of the soldiers would strike her again.

cave that was her headquarters. There, the shepherdess told her, "I heard some of the soldiers talking earlier. They said Hercules has been spotted nearby."

Xena's eyes lit up. "Hercules?"

With Xena cast out, Salmoneus knew his days were numbered. Darphus did not seem to appreciate his finer qualities.

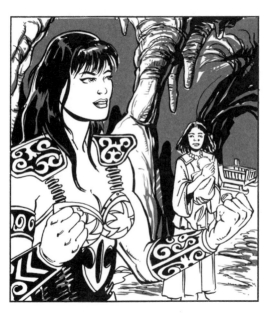

"Hercules?"

So he ran. All night he ran through the forest, trying to put distance between himself and Darphus' army.

Eventually, he ran right into Hercules. When Salmoneus told him that Xena's army was headed for Parthis, the son of Zeus assured Salmoneus that he would stop Xena's evil.

"She's not as evil as you think," Salmoneus told him. "At least she

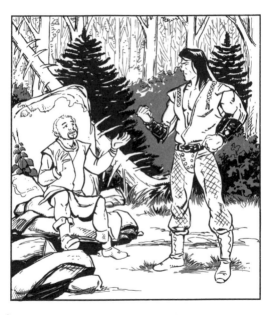

"She's not as evil as you think."

allows her victims to surrender. She's not into that scorched-earth policy like Darphus."

Salmoneus might have convinced him, but a few moments later, Xena herself appeared, standing squarely in their path, and challenged Hercules to a duel. She claimed that if she could bring Hercules' head back to her army,

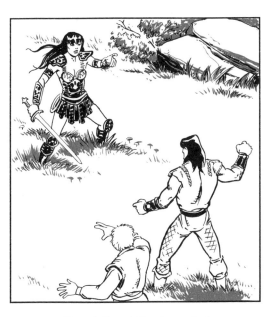

Xena challenged Hercules to a duel.

they would be impressed and she would have her army once again.

"Why?" Hercules growled. "So you can kill more women and children?"

"That was not my idea!" Xena roared. Then she charged.

Hercules was far stronger, but Xena was quick and cunning. She nearly sliced off Hercules' head with her chakram before he knocked it away with a

She nearly sliced off Hercules' head with her chakram.

boulder. Then they closed the distance, battling with swords. Hercules dodged dozens of lightning-fast strokes until he got close enough to use his strength. Grabbing hold of Xena's arm, Hercules tossed her head-over-heels. She hit the ground hard, and when she tried to rise, she felt the cold metal of Hercules' sword tickling her throat.

"Go ahead and end it," Xena said

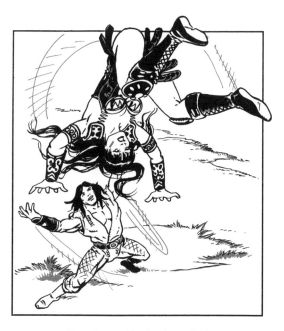

Hercules tossed her head-over-heels.

defiantly. "Prove you're the greatest warrior."

"Killing isn't the only way to prove you're a warrior," the son of Zeus replied.

Sheathing his sword, Hercules pulled the Warrior Princess to her feet. "I'm going after your army. Why don't you join us?"

"Killing isn't the only way to prove you're a warrior."

Xena glanced at him for only a moment. "No."

Once again, she vanished into the forest.

Racing against time, the heroes reached Parthis at dusk, well ahead of Darphus and his army. With ample warning, the entire town was able to evacuate, leaving only

The heroes reached Parthis at dusk, well ahead of Darphus.

Salmoneus, Spiros, Iloran, and Hercules to defend it.

"The villagers have cooked up a few tricks," Hercules assured Salmoneus. "We'll be all right."

But it was hard to remain calm, and dozens of flaming torches appeared on the horizon. Screaming like ghosts from Tartarus, the raiders attacked,

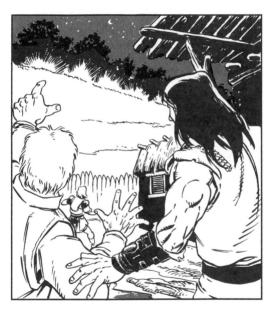

Dozens of flaming torches appeared on the horizon.

scrambling over walls and bursting through unlocked gates.

Salmoneus waited as a band of soldiers ran beneath a stone balcony, then he yanked on a rope. The trap sprang, and a cache of stones rained down, burying the soldiers. Iloran and Spiros followed suit, springing traps that buried the attackers beneath wood and debris.

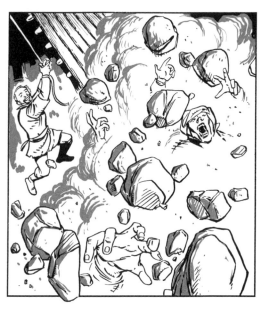

A cache of stones rained down, burying the soldiers.

In the center of the town stood Hercules. Darphus' men swarmed over him. Hercules dropped one, two, three, and then more of the soldiers. But they were too much, even for him. In moments he was buried beneath a pile of bodies.

"Aiiilalalalalalalalal!"

A war cry sounded over the town. Xena leapt down from a housetop,

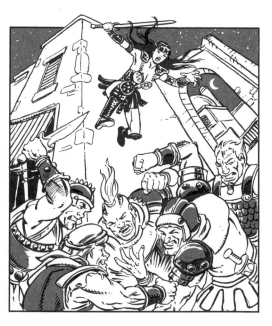

"Aiiilalalalalalalalal!"

crashing into the pile of soldiers and sending them sprawling. Xena had returned!

Hercules shrugged off his attackers and rejoined the battle. The soldiers were no match for Xena and Hercules combined. As more of their ranks fell, the warriors turned and fled.

Only Darphus stood his ground.

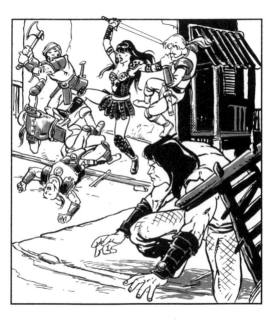

Xena had returned!

"Fight, fight!" he ordered, but his men ignored him.

Catching sight of the evil warrior, Xena charged. Their swords rang, and their battle was so fierce it echoed through the meadows of Arcadia.

Xena was the better warrior. She dropped to one knee to avoid a strike, and as Darphus leaned in for a killing blow, Xena raised her sword. The

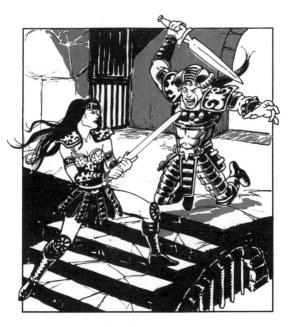

*As Darphus leaned in for a
killing blow, Xena raised her sword.*

blade pierced Darphus' heart, and the man dropped dead instantly.

As the dust settled over the battle, Hercules smiled at Xena. "Glad you're back."

Xena shrugged. "I had to come back. They weren't true warriors. They had to be stopped."

Hercules nodded, then looked into Xena's eyes, searching for the truth.

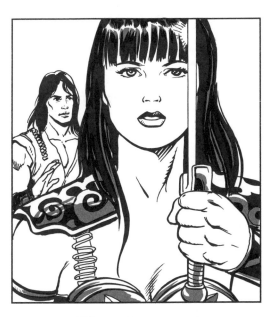

"They weren't true warriors."

"Is it over now?" he asked.

Xena nodded. "Yes."

As she spoke, Spiros appeared. "Xena, Salmoneus tells me you saved a baby from my village. Did he have a birthmark on his left leg?"

Xena was surprised. "Why . . . yes."

Spiros' eyes lit up. "Th-that's my son! My son!"

Eagerly, Spiros dashed off to find

"Th-that's my son! My son!"

him, with Salmoneus in tow, leaving the two great warriors alone again.

Hercules sighed. "So . . . what now?"

Xena shrugged. "What do you say we go find out together?"

Long after they had left the battle site, a dark, cloaked figure strode among the bodies. The shadowy figure pulled the sword from

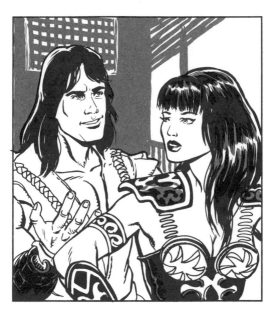

"What do you say we go find out together?"

Darphus' heart. Life returned to his dead limbs. Slowly, the warrior rose.

"Who are you?" asked Darphus in a voice from beyond the grave.

The cloaked figure spoke. "An emissary of Ares."

"The God of War? What does he want with me?"

"To give you your revenge on Xena,"

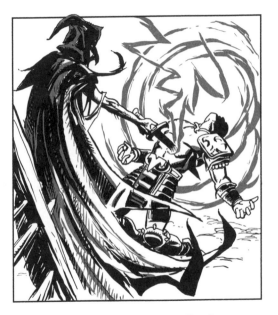

"To give you your revenge on Xena."

the shadowy visitor declared. "And the chance to destroy Hercules!"

As he waved a gnarled hand, a beast appeared from the shadows. The creature stepped forward on one massive paw and the ground trembled. Ares had sent Graegus, his immortal dog of war, to destroy Xena and Hercules.

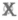

A beast appeared from the shadows.

Not long after the battle, Xena, Hercules, and Salmoneus were resting in a village square when a messenger appeared.

"Hercules!" he gasped. "You've got to go to Elysia!"

"What's wrong?"

"Invaders. Led by a warrior called Darphus."

Xena stiffened. "Can't be. He's dead."

THIRD SCROLL

The messenger looked at the Warrior Princess. "By your hand, if you're Xena. I saw a huge, gaping hole in the middle of his chest."

"Only the gods have the power to bring Darphus back from the dead. And I'll bet I know which one," Hercules sighed.

Xena leaped to her feet. "That

"Only the gods have the power to bring Darphus back from the dead."

means nothing to me. I'm still going to Elysia to stop Darphus."

"No," Hercules said, rising beside her. "*We're* going to stop him."

In Elysia, Darphus watched as a gang of new prisoners was dragged toward the center of the town he had conquered. He had been a cruel man in life. Now, raised from the dead by Ares, he was truly heartless.

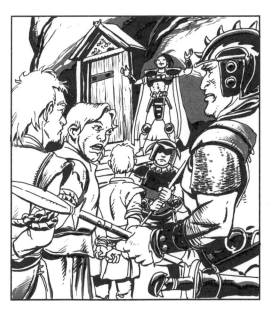

Raised from the dead by Ares, Darphus was truly heartless.

He pointed toward one of the prisoners. "Take that one to the temple."

His soldiers dragged the helpless victim to a temple at the very center of town and threw him in. The poor wretch stumbled down into the darkness of the ruined building.

Inside lurked Ares' gift to Darphus. It was the monster Graegus, who grew large and powerful on sacrificial

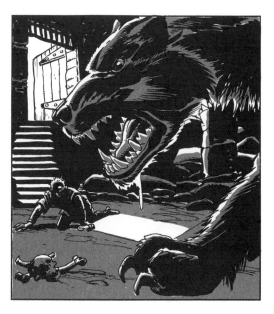

Inside lurked Ares' gift to Darphus.

victims. Huge, with gaping jaws and rows of sharp teeth, Graegus waited to be fed.

For a moment, the prisoner heard nothing but his own whimpering. Then, a low, supernatural growl filled the dark chamber. The growl became a roar, and the prisoner screamed as something huge lunged out of the shadows and swallowed him whole.

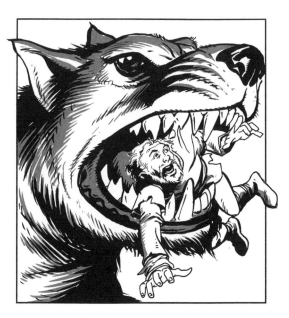

Something huge lunged out of the shadows.

Xena, Hercules, and Salmoneus made good time on the first leg of their journey to Elysia. While they set up camp, Xena went ahead to scout the territory.

As they waited, a visitor arrived at their camp.

"Iolaus!" Hercules shouted. "What brings you to these parts?"

"Iolaus! What brings you to these parts?"

A shadow fell across Iolaus' face. "Xena. She's on the loose again."

"Xena?" Salmoneus said. "No, actually—"

But Hercules interrupted. "Don't you have quail to catch?" He turned back to Iolaus. "It's not Xena we have to worry about. Our real problem is with a warrior named Darphus. He's

"It's not Xena we have to worry about."

slaughtering everyone in sight for the greater good of Ares."

Salmoneus busied himself with quail hunting, and by nightfall the three of them were feasting over a campfire. Finally, Hercules said, "Iolaus, there's something I've been meaning to tell you. It's about Xena."

Before he could continue, Xena

"Iolaus, there's something I've been meaning to tell you."

herself stepped from the shadows. "Hello, Iolaus."

The blond warrior leaped to his feet, reaching for his weapons. "What's she doing here?"

Hercules tried to calm him. "We're on the same side, now."

"Darphus knows we're coming," Xena said. "I ran into some of his warriors, but one of them got away."

"We're on the same side, now."

Iolaus was furious. "Hercules, you're falling for the same trap I did!"

He stormed off into the woods, with Hercules close behind. Hercules did his best to explain the change in Xena. He pleaded with Iolaus to join them against Darphus and his army.

Iolaus was unconvinced. "Count me in. But both of us better watch our backs."

"But both of us better watch our backs."

Hercules knew of a diamond mine that lay nearby, so they stopped by to warn the miners of Darphus' rampaging army. But they cared nothing for the danger, or for Darphus.

"If the name Darphus doesn't scare you," Hercules said, "maybe the name Ares will."

The miners only laughed. "There's not a man here who hasn't paid tribute

"If the name Darphus doesn't scare you, maybe the name Ares will."

to him by fighting in a war some-
where. He bears us no ill will."

But as he spoke, the hum of a flying
arrow filled the air. Hercules whirled,
and snatched the arrow in mid-flight,
just before it pierced the miner's heart.

"You were saying?" Hercules asked.

Darphus' soldiers poured into the
camp. Hercules, Xena, and Iolaus
went into action, protecting the

"You were saying?"

miners as they fled. Weaponless, Hercules fought with his hands, tossing soldiers aside like bundles of wheat.

Iolaus dropped several before they could clear their weapons, but three warriors fell on him. Two pinned his arms at his sides while a third raised a dagger.

The dagger never fell. A whip wrapped itself around the soldier's

The dagger never fell.

wrist and dragged him away, allowing Iolaus to break free of the other two. When he turned to see who had saved him, he was stunned.

It was Xena.

Without pausing, Xena dropped the knife-wielder, grabbed his dagger, and whirled to find Darphus. The warlord sat atop his horse, surveying the battle. He only grinned as Xena aimed

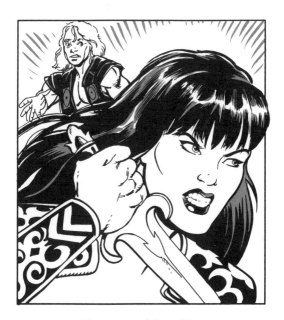

He was stunned. It was Xena.

and hurled the knife. The blade sank into his chest.

Darphus only laughed. Carelessly, he pulled the knife from his body and tossed it aside. "Don't you know you can't kill me? Ares is on my side."

But if Darphus couldn't be killed, his soldiers could. Hercules and the others were taking a terrible toll on his

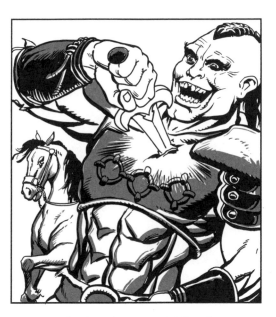

"Don't you know you can't kill me?"

army. Cutting his losses, Darphus sounded the retreat.

As the warriors fled, Hercules yelled, "We're coming after you, Darphus!"

The warlord laughed. "I'll be waiting."

Xena watched him ride away. "If a knife in the heart won't kill Darphus, what will?"

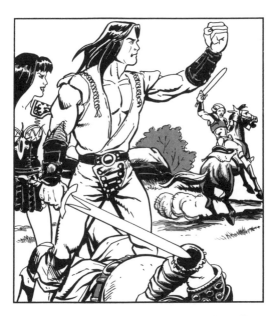

"If a knife in the heart won't kill Darphus, what will?"

"We have another problem," Iolaus said. "Salmoneus is missing."

The heros gave chase, but darkness fell faster than they could travel, and they stopped for the night. Iolaus went ahead to scout out their path, and while they were alone, Xena told Hercules how she felt, having begun to help people instead of hurt them.

"Is this how it feels to be you?"

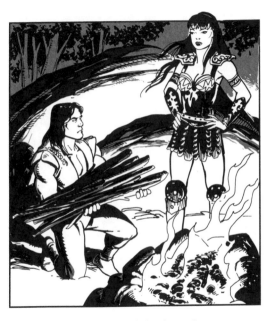

"Is this how it feels to be you?"

"I think you're finding out how good it feels to fight the forces of evil," Hercules replied.

"I wouldn't be doing it if you hadn't given me the chance," Xena said softly.

Hercules answered quietly, "You made the decision on your own."

"There's another decision I've made. To tell you how I feel about you in case I die fighting Darphus."

"I wouldn't be doing it if you hadn't given me the chance."

Leaning forward, she kissed him passionately. The son of Zeus and the Warrior Princess melted together.

Iolaus returned to find them sitting quietly in the glow of the campfire. He paused only for a moment to report what he had seen. He had scouted all the way to Elysia and brought back two pieces of news.

The son of Zeus and the Warrior Princess melted together.

"I saw Salmoneus and Darphus eating together! They looked like they were having a good time."

Hercules frowned. "Salmoneus is a lot of things. But I can't believe he's a traitor."

"There's something else," Iolaus added. "Hercules, Graegus is there."

"Who's Graegus?" Xena asked.

"Ares' pet," the son of Zeus replied.

"I can't believe he's a traitor."

"He'll feed on Darphus' victims until he's the biggest creature that ever walked."

"And if that happens," Iolaus said ominously, "Ares will rule the world."

"What are we going to do?" the Warrior Princess asked.

Hercules smiled thoughtfully. "Sometimes you can only fight evil with evil."

"Sometimes you can only fight evil with evil."

⟜⟜⟜◯ Iolaus *had* seen Salmoneus eating with Darphus, but the warlord was only fattening up the poor man for Graegus. When they'd filled him full of bread and butter, they dragged him to the temple and chained him to the floor. The first sight of the beast terrified him.

Graegus was huge, with cracked and gnarled skin, massive jaws, and rows

They dragged him to the temple and chained him to the floor.

of jagged teeth. Seeing his next victim, Graegus roared!

Salmoneus would have died at that moment, if not for the bravery of Xena and the others. Reaching Elysia, they charged headlong into Darphus' army, scattering soldiers before them.

At the steps of the temple, Darphus only laughed. "So the son of Zeus has finally arrived!"

"So the son of Zeus has finally arrived!"

Hercules charged up the steps to the temple door. He ducked beneath Darphus' sword and punched the warlord squarely on the jaw. "Stay," he grunted as Darphus crumpled to the ground.

Hercules reached Salmoneus a few seconds before the monster. Grabbing a spear, he drove Graegus back, but the huge jaws snapped the weapon

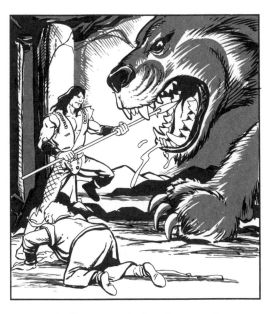

Grabbing a spear, he drove Graegus back.

like a twig. As Graegus charged, Hercules dove behind a huge metal gong and used it as a shield to keep the monster at bay.

Outside the temple, Iolaus kept the soldiers busy while Xena hunted for Darphus. Finding him at the temple, she snarled, "I'll make sure you stay dead this time!"

But Darphus fought with the power

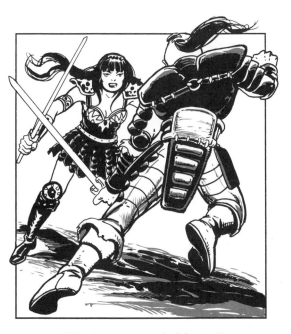

"I'll make sure you stay dead this time!"

of Ares. Xena soon found herself stumbling back, down into the temple. Breaking free from combat with the warlord, Xena snapped Salmoneus' chains with a single sword stroke.

"Salmoneus, get out of here!"

Salmoneus ran from the temple. Snatching up a heavy pot, he used it as a club to help Iolaus. Every time the blond warrior softened up one of

"Salmoneus, get out of here!"

Darphus' soldiers, Salmoneus put him out for good.

But the real battle raged inside the temple. Xena and Darphus fought to a standstill. The ringing of their swords mixed with the hungry roars of Graegus as the monster sought to catch Hercules in its jaws.

The son of Zeus knew he could not dodge the creature forever. Spotting a

The monster sought to catch Hercules in its jaws.

chain tied to a pillar, Hercules wrapped it around the monster's foot, then leaped back. Graegus lunged, but he was leashed to the pillar. His jaws snapped inches from Hercules' face.

"Xena! Let's put evil in its place!"

As Hercules ducked, the Warrior Princess kicked Darphus. The warlord tripped over Hercules and stumbled right into the waiting jaws of Graegus!

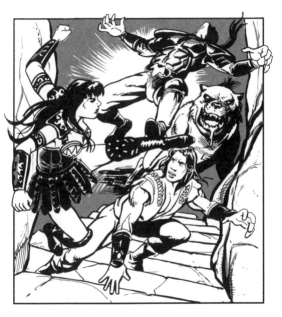

"Xena! Let's put evil in its place!"

"No!" Darphus screamed.

The mighty jaws closed. But a moment later, Graegus squealed. Its body trembled, then burst into flame! The monster gave one final, deafening roar, then collapsed into nothingness.

Iolaus entered in time to see the flames die out. "What happened?"

Hercules heaved a sigh of relief. His plan had worked. "Evil defeated evil."

"Evil defeated evil."

Though Darphus was dead, there was no peace in the heart of Xena.

Hercules found her packing her belongings onto her horse.

"You're leaving?" he asked, his voice trembling.

Xena blinked, unwilling to look at him. "You're going to make me cry," she whispered. "I haven't done that since I was a child."

"You're going to make me cry."

Gently, he kissed her. But after a moment Xena pulled away. "Let me go. There's so much in my life I have to make amends for."

Hercules nodded. "But I wish you'd let me help."

"You already have," the Warrior Princess replied. "Goodbye, Hercules."

"There's so much in my life I have to make amends for."

Xena had turned a corner and found a new role in life. But her past haunted her. Scenes of bloodshed and violence tormented her.

As if to punish herself, Xena wandered through ruined villages—villages she had destroyed—to witness firsthand the pain she had caused.

In one ruined village, a starving boy

FOURTH SCROLL

ran up to her horse. "You got any food to spare?"

"Where are your parents?" the Warrior Princess asked.

"They were killed by Xena."

Choking back tears, Xena tossed him the last of her own food, and rode on.

Before she reached the next village, Xena veered off the road and into the woods. There she stripped off her

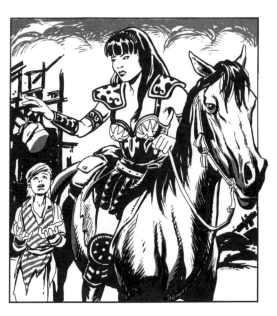

"They were killed by Xena."

armor and weapons and buried them in the earth. With them, she hoped to bury her past.

Screams filled her ears, and for a moment she thought she was reliving memory—but peering through the bushes, Xena saw a band of marauding warriors gathering up women from the nearby village.

As the Warrior Princess watched,

*Xena stripped off her armor and
weapons and buried them in the earth.*

one of the women stepped forward. "Take me. Let the others go!"

"Gabrielle, no!" called one of her companions.

The warrior captain laughed. "Nice try. But we'll take you and anybody else we want."

The warrior raised his whip, but Xena leaped out of the bushes and snatched it from his hand. The

"Take me. Let the others go!"

warrior laughed again. "This village raises tough women." Still grinning, he drew a knife.

But Xena was far too quick for him. Before he could strike, she kicked him a dozen times, sending the man sprawling.

Another marauder lunged at her with a spear, but a kick sent the weapon flying into the air. As it landed, Xena

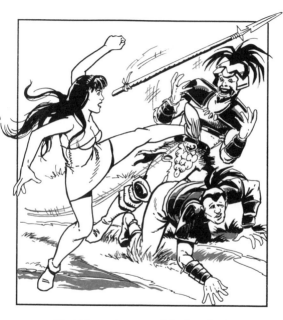

Her kick sent the weapon flying into the air.

leaped for it and whipped herself around, kicking warriors as she did!

As her enemies fell, Xena caught sight of the brave young village woman being dragged away. Snatching up the spear, she hurled it at the warrior, freeing the captive. But the action distracted her—another soldier struck her from behind, and

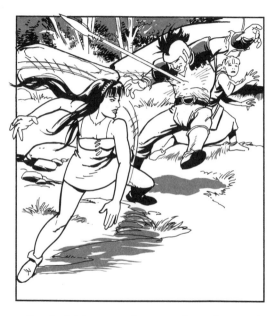

Xena hurled the spear at the warrior, freeing the captive.

Xena fell. Before she could recover, she was surrounded.

Instead of fighting, Xena cowered down. Her hands dug into the earth —for beneath her lay the spot where she had buried her weapons!

The warrior captain stood over her and raised his sword. As it fell, the Warrior Princess raised her own flashing sword to block it! Out came

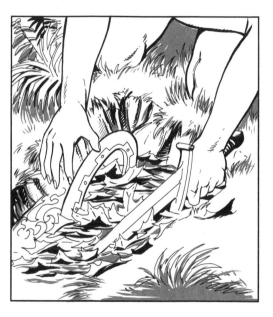

Her hands dug into the earth
where she had buried her weapons!

her flying chakram, hurtling through the air, snapping a half dozen sword blades before returning to Xena's hand. Armed once more, Xena was more than a match for the soldiers. In moments, all but the warrior captain lay unconscious.

Xena recognized the markings on the man's armor. "You're with Draco. Tell him Xena says hello."

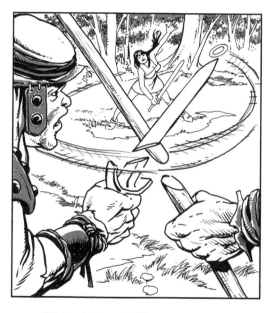

"You're with Draco. Tell him Xena says hello."

A short time later, Xena sat in one of the villagers' homes, tending to her wounds. Gabrielle, the young woman she had saved, stood before her.

"That thing you did with the chakram, that was amazing. And that kick you do, you've got to teach me that!"

Before Xena could reply, a group of village elders entered. Their leader,

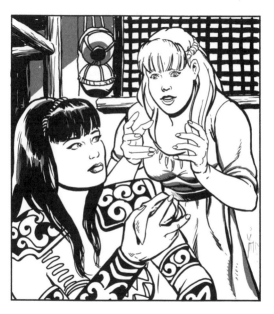

"That thing you did with the chakram, that was amazing."

Gabrielle's father, spoke bluntly. "You've got to move on. We don't want any trouble with you, Xena. We know your reputation."

Gabrielle was shocked. "But father, she saved our—"

"It's all right," Xena said wearily. "I have to move on anyway."

Satisfied, the villagers backed away.

"You've got to move on, Xena."

One of them, a tall, clumsy fellow, said, "Let's go, Gabrielle."

"Hey!" the young woman snapped back. "Just because we're betrothed doesn't mean you can boss me around. I want to stay and talk with Xena." The man cast a scowl at Xena, but left.

Gabrielle shook her head as he departed, then said to Xena, "You've got to take me away from here. Teach

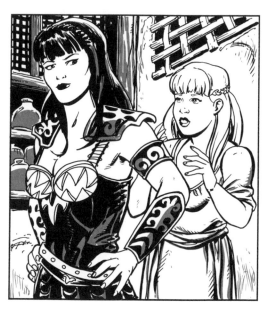

"You've got to take me away from here."

me everything you know. You can't leave me here."

"Why?"

"Did you see the guy they want me to marry?"

Xena shrugged. "Seems like a gentle soul."

"It's not the gentle part I have a problem with. It's the dull, stupid part!"

"Did you see the guy they want me to marry?"

The Warrior Princess shook her head. "I travel alone."

Gabrielle frowned. "So where are you headed?"

"Amphipolis," Xena replied. Then her eyes turned hard and cold. "And don't think about following me."

A few miles away, the camp of the warlord Draco was astir. The soldiers were preparing for their next

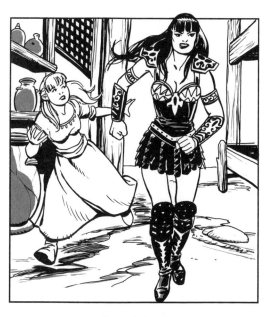

"I travel alone."

campaign. In his tent, Draco sharpened his weapons as a shadowy figure slipped quietly into the pavilion.

"Hello, Draco."

The warlord whirled around. "Xena! What are you doing here?"

The Warrior Princess met his powerful gaze easily. "I want you to spare the village where your men fought today."

"I want you to spare the village where your men fought today."

Draco considered. "I could have mercy on that village. If you join with me. We'd make an invincible team."

Xena shook her head. "I can't do it. I'm going home."

"Home?" Draco said. "I've dreamed of being with you. At your side or against you in battle. But now you won't give me the satisfaction of either." He scoffed. "What do you

"We'd make an invincible team."

intend to find in Amphipolis? Forgiveness? They'll never give it to you."

Xena feared that Draco was right, but she had to try. Without another word, she slipped quietly from his tent.

Once she had gone, Draco assembled his captains. He had wanted Xena for years. Now he saw a way to get her, either into his bed, or into battle. Pointing to a map, he declared,

Draco saw a way to get Xena
either into his bed, or into battle.

"We'll march right to Amphipolis and torch everything in sight. And spread the word, we're doing it on Xena's orders. Then she'll know—there's no rest for the wicked!"

Xena was on the road to Amphipolis when she spotted three soldiers following her. Doubling back, she moved with the quiet of a jungle

"Then she'll know—there's no rest for the wicked!"

cat, and pounced on two of them before they could make a sound.

The third—the same captain she'd defeated before—soon fell at her feet. "What does Draco want?" she demanded.

The man hesitated, but at the moment he feared Xena more than he feared his warlord. "He plans to destroy your home valley."

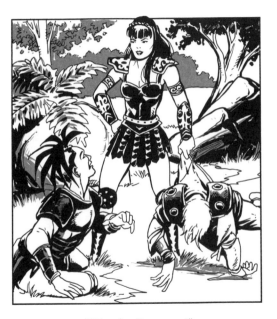

"What does Draco want?"

Riding hard, Xena reached the beautiful valley where she was born. Small farms dotted the slopes of the valley, and the peaceful songs of farmers rose up to meet her like childhood memories. She hurried toward an all-too-familiar tavern. As she entered, every voice in the tavern stilled. A woman, her face filled with sorrow, pushed her way through the crowd.

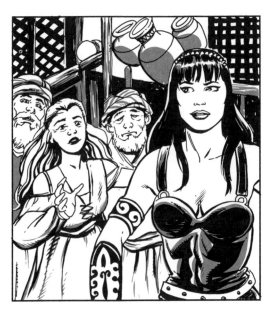

As she entered, every voice in the tavern stilled.

"Mother," Xena whispered.

Without a word, the woman pulled Xena's sword from its sheath. The Warrior Princess did not stop her.

"Weapons aren't welcome in my tavern," Xena's mother said. "And neither are you."

"Mother, listen. The warlord Draco is marching on this valley—"

"And you need to borrow a few men

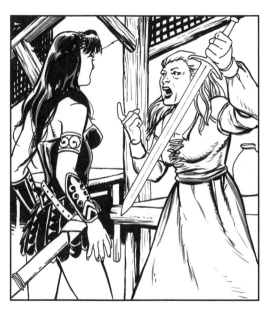

"Weapons aren't welcome in my tavern. And neither are you."

to raise an army, right?" her mother scoffed. "We all remember what happened last time you talked like that!"

"But you're all in great danger!"

Her mother's eyes flashed with years of pent-up anger. "Even if that were true, we would rather die than accept help from you again! I don't think anything could take away the shame you've brought on your kinsmen."

"We would rather die than accept help from you again!"

Xena lowered her gaze, feeling the sins of her past weigh heavily on her. "Probably not. But I'll spend the rest of my life trying."

"There she is!"

A crowd of villagers entered, all carrying stones. One of them cried, "Her army is burning fields in the west valley!"

"Her army is burning fields in the west valley!"

Xena was stunned. "That's a lie. It's Draco's army."

"Then why are they shouting your name?" demanded one.

"You should never have come back!" another shouted angrily.

Xena understood the look in their eyes. She knew they had brought stones to throw at her. "What are you waiting for?" she said. "Take your revenge."

"What are you waiting for? Take your revenge."

As the first man raised a stone to cast, the young woman Gabrielle pushed her way through the crowd. She had trailed Xena all the way to Amphipolis.

"Wait!" she cried. "I can assure you, Xena is a changed woman. I saw her do some heroic things in the name of good!"

"Xena is a changed woman."

"You're wasting your breath," the villagers spat.

Gabrielle knew she could not calm their hatred, but maybe she could use their fear. "Let's say you're right, and she's Draco's buddy. Maybe even his girlfriend. You think that Draco's bad news now? What do you think he'll be like when he hears you've knocked off his woman?"

"You're wasting your breath."

The villagers paused. They knew they could not afford to anger Draco further. "All right. But get Xena out of here right now."

Outside, night was falling over Amphipolis as Xena saddled her horse.

"Wait!" Gabrielle called. "You can't just leave me here. I came all this way to see you."

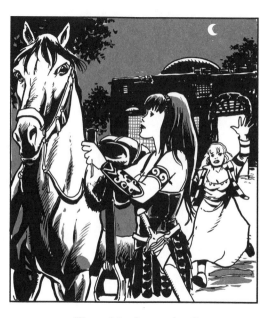

"You can't just leave me here."

"That's your problem," Xena said, leaping to her horse's back.

"I just saved your life!" the young woman protested.

Xena frowned. She didn't want company, but a debt was a debt. Reaching down, she pulled Gabrielle atop her horse, and together they rode out of the village.

Xena rode straight to an

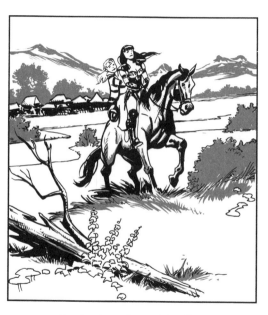

Together they rode out of the village.

ancient tomb. Inside lay a stone coffin, the grave of her father. She stood over the coffin, speaking to the man she had loved years ago, long before she had become the terror of the land. "I thought I could start over," she whispered. "They don't trust me. Not even Mother. I wish you were here. It's hard to be alone."

Gabrielle crept quietly in behind

"It's hard to be alone."

her. Softly, the young woman said, "You're not alone."

While Xena mourned, the villagers requested a meeting with Draco. Amused, the warlord rode into the village and met with them in the town's main hall. Desperately, the villagers offered to supply Draco's army with food, as long as they were left alone.

Draco rejected their offer instantly.

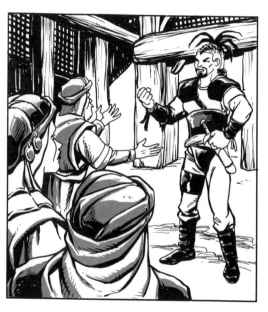

Draco rejected their offer instantly.

He cared nothing for their food or their possessions. "But you do have something I want. Xena."

The village elder shook his head. "She's not here."

"Where is she?" Draco demanded.

"I don't know—ahh!"

Draco struck him before he could finish his sentence. "You lying sack of—"

"You lying sack of—"

"He's not lying."

Draco spun around. In the doorway stood Xena. "Hello again, Draco."

The warlord smiled. "I want you. One way, or the other."

Xena's eyes were cold. "I choose the other."

"Then choose the weapons!" Draco barked.

"I choose the other."

"You choose the weapons, I choose the conditions."

"Staffs," Draco said.

Xena nodded, pointing to a platform in the middle of the hall. "Up on that scaffolding. The first one to touch the ground dies."

Both warriors leaped up to the scaffolding. Draco struck like a serpent, but Xena blocked his attack and

"The first one to touch the ground dies."

fought back. The power of their blows shook the platform beneath their feet, and Xena suddenly felt her foothold slip away. The scaffolding was coming apart!

Abandoning the platform, Xena jumped onto the support beams. To even the field, she smashed the floor boards beneath Draco's feet. Surprised, the warlord lost his balance.

The scaffolding was coming apart!

Seizing her advantage, Xena struck him hard, throwing the warlord off the platform.

But Draco was no easy kill. He leaped from the platform and landed on the shoulders of the spectators. Xena followed. Using the heads and shoulders of the villagers as stepping stones, the two warriors continued their duel. Xena blocked a powerful

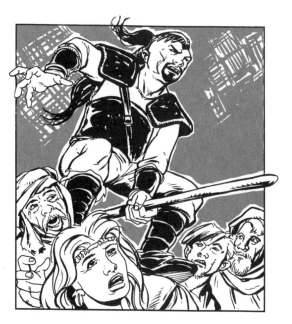

Draco landed on the shoulders of the spectators.

blow from Draco and spun around, delivering a kick that broke the warlord's balance. Launching herself into the air, Xena landed a second kick that sent Draco flying.

One of the warlord's men dashed forward to catch his commander, but instead fell sprawling to the ground. Gabrielle had tripped him!

Draco hit the floor hard, and Xena

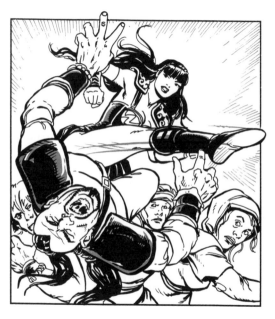

Xena landed a second kick that sent Draco flying.

jumped after him, landing heavily on his chest. "I haven't touched the ground yet, but you have. Looks like I'll have to finish you off myself. Unless you want to make a deal. If I let you live, you and your army clear out of the valley by sundown."

Draco had no choice but to agree.

Xena let him rise, but as she did, one of Draco's soldiers drew a dagger and

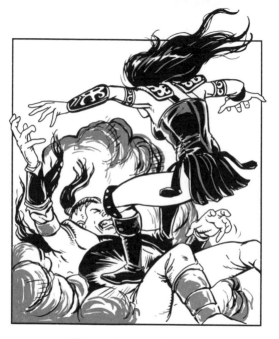

"If I let you live, you and your army
clear out of the valley by sundown."

lunged at her. Faster than one of Zeus'
thunderbolts, Draco hurled a knife,
killing his own man!

The warlord shrugged. "A deal's a
deal."

Xena waited only long enough
to make sure Draco's army had left the
valley peacefully. Then she prepared
to leave as well.

Her mother found her and, without

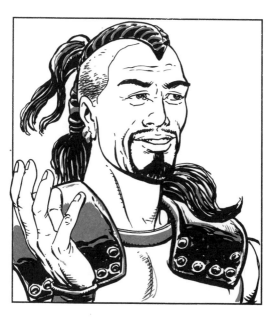

"A deal's a deal."

a word, wrapped her arms around her daughter in a warm embrace.

"Mother," Xena whispered, "please forgive me."

"I do, my child," her mother replied. "I do."

Despite her mother's forgiveness, Xena could not stay in Amphipolis. There was too much goodness she

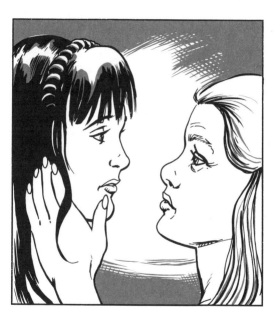

"Mother, please forgive me."

owed the world. But she left Amphi-
polis knowing she had rid herself of at
least some of her demons.

She could not, however, rid herself
of Gabrielle. The stubborn young
woman found her the first night she
made camp. Xena shook her head.
"You know I'm sending you home in
the morning."

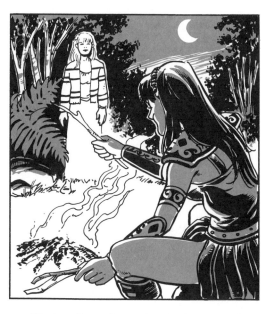

"You know I'm sending you home in the morning."

"I won't stay there," Gabrielle insisted. "I'm not the little girl my parents wanted me to be." She paused. "Maybe you wouldn't understand."

But Xena understood all too well. "It's not easy proving you're a different person."

The next morning, they walked together toward the future.

"It's not easy proving you're a different person."

"You know," Xena said, "where I'm headed there'll be trouble. Why would you want to go into that with me?"

Gabrielle smiled. "That's what friends do."

Xena laughed. It was a word she had never used with anyone before. But it seemed to fit. "All right. Friend."

THE END

"That's what friends do."

JOIN THE OFFICIAL

XENA
WARRIOR PRINCESS

FAN CLUB!

FOR INFORMATION WRITE:

664-A W. BROADWAY
GLENDALE, CALIFORNIA 91204

OR JOIN ONLINE:

WWW.CREATIONENT.COM

Packed with non-stop action,

MIGHTY CHRONICLES™

are the little books with the big punch.
Look for other titles in
this exciting series, including
Hercules: The Legendary Journeys™,
Star Wars®, The Empire Strikes Back™,
Return of the Jedi™,
The Lost World™, The Mask of Zorro™,
Raiders of the Lost Ark™,
Terminator™ 2

Collect them all!